Intr

The images depicted in this *Easy* [...]
of ceramic bowls by Mimbres India[...]
who lived in the Southwest about [...] on their bowls is
the best evidence remaining of Southwestern Indian mythology and
culture. Their paintings are virtual time capsules, windows to peak through
into the legends of prehistory. Welcome to a small keyhole. To gain a larger
view and explanation we recommend: *Mimbres Mythology Tales from the
Painted Clay* also written by James R. Cunkle.

The painted bowls depicted here are well preserved because they were
buried with the dead. The Mimbres Indians placed bowls over the face of
the deceased and carefully chipped a small hole in the bottom of the bowl.
This "kill hole" is visible in several of the examples shown in our Easy Field
Guide®. The ritual was thought to free the spirit of the bowl to travel with
the deceased to the next world.

Please note the illustrations in this guide are accurate reproductions. The
interpretations are researched conjecture.

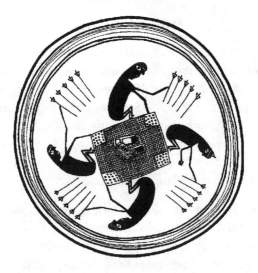

Many bowls are painted with scenes of day-to-day life that reveal a wealth of information to researchers. Depicted at the center is a gambling blanket. Apparently the wager is one arrow. One player holds a small cup that contains the dice he is about to throw. These dice and the gaming tokens were made from pieces of broken pottery.

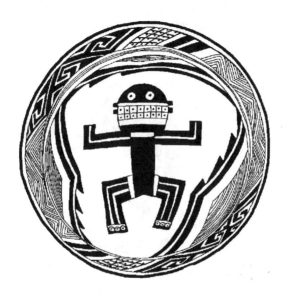

The prayer stance with both arms raised is often exemplified in rock imagery and ceramic paintings. Here it is combined with a grid/dot pattern on the bowl's rim and figure's mouth symbolizing corn. This combination most likely represents a prayer for a plentiful corn crop.

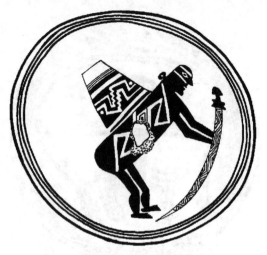

The figure is Kokopelli, a popular character in prehistoric Southwest mythology. Depicted in ceramics, petroglyphs, cave murals and virtually anywhere symbols survive, Kokopelli usually has a humpback. Sometimes he is described as a trader bringing exotic goods to the pueblos of the Southwest. In this painting, the backpack seems to be heavy. Note the "kill hole" in the center of the bowl.

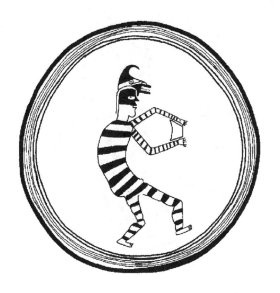

Hopi and Zuni as well as Mimbres art depicts tricksters like this one in black and white stripes. The headdress is that of Quetzalcoatl, a deity of distant southern neighbors the Toltec and Mayas. Perhaps this verifies the commerce attributed to Kokopelli.

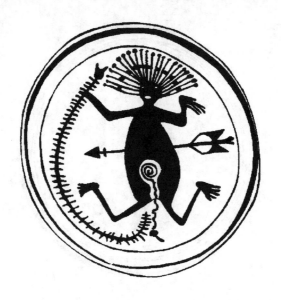

The figure has been shot with an arrow and his life breath is escaping, as represented by the spiral. He is holding a large centipede representing the one-pole ladder used to climb from one level of existence to another.

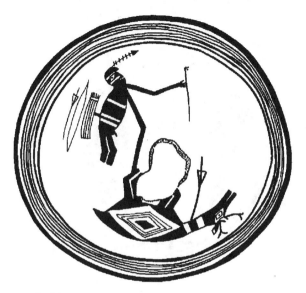

The bow hunter holds a prayer stick above the deer and blesses the animal for providing food for the people. Prehistoric hunters thanked the animal directly for willingly participating in the sacrifice so the spirit of the animal will reincarnate and return again.

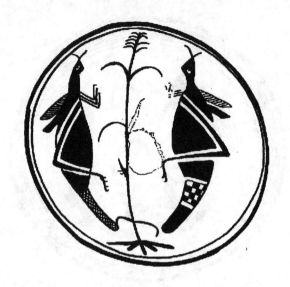

Even though corn was a main cereal grain and very important to pueblo life, it was rarely illustrated alone; usually depicted with animals, birds or insects. Here, two locusts surround a corn plant. Interestingly, the illustration includes the roots as well as leaves and tassels of the plant.

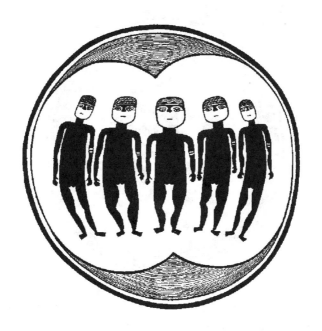

The figures are Corn Maidens, the symbol of renewal. The headbands on the figures symbolize kernels of corn.

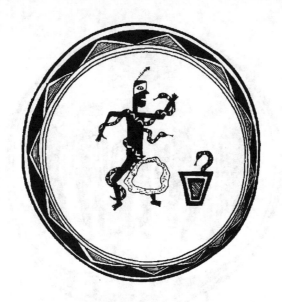

This bowl is illustrated with a man fearlessly handling rattlesnakes. Many religions regard snake handling as a proof of faith or test of invulner- ability through faith. The Hopi Snake Dance is still performed using live rattlesnakes.

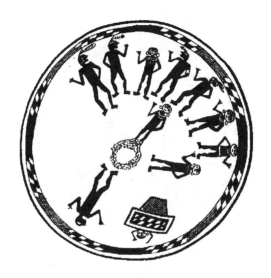

Nine of the men and women appear to be voting. They have either their right or left hand held aloft and the other hand on their hip. The figure with both hands in the air and his fingers in counting posture is likely counting the vote. To his right there is a woman contained in what may be a large basket. Is the vote deciding her fate?

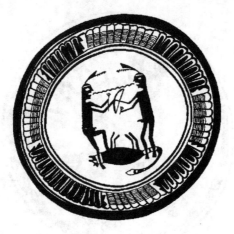

A recurring symbol is a wavy line that extends from the mouth of two animals of the same species. In this painting of two hunters, a mountain lion has been killed and an argument ensues over possession of the animal. Extending from the mouths of both hunters is a wavy line undoubtedly symbolizing the ongoing contention. Wavy lines representing communication have also been shown between birds, as is shown on the front cover of this book.

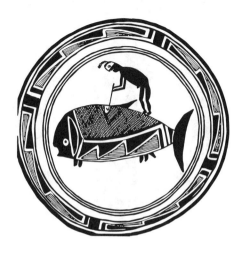

This illustration can be interpreted in several ways. Perhaps it reflects an encounter with a whale, possibly in the Sea of Cortez. The Mimbres traded for ocean shells, and an expedition as far west as the Pacific Ocean may have occurred. However, recognizing the overstating nature of many fishermen describing their catch, this image may depict a tall tale or mythic event.

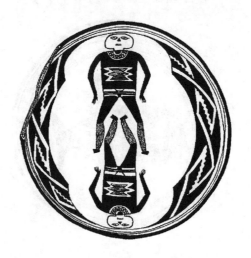

The Warrior Twins are two characters that often appear in the mythology of the Pueblo Indians. Their names are Brother Elder and Brother Younger. They were born of a magical conception from the seed of Father Sun unto their mother Changing Woman. After seeking their father in a rite of passage quest, they then go about the earth helping to bring the rains and to rid the world of monsters.

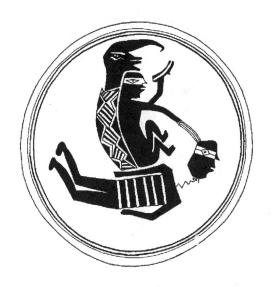

Brother Elder wearing a plumed serpent costume is pretending to decapitate Brother Younger. This performance is staged to fool the gods. Notice that the head of Brother Younger is still connected to his body by one thin thread.

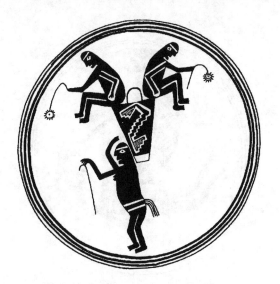

In this depiction Spider Grandmother is carrying the Warrior Twins in a basket. Her role in Pueblo mythologies resembles that of a fairy godmother who dispenses magical objects. Her staff symbolizes authority. Her basket doesn't always carry the Warrior Twins. On the front cover, you see her with an exotic parrot.

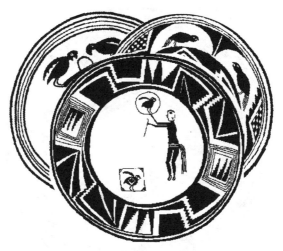

Macaw parrots were traded from central Mexico a distance of over 1200 miles. They were highly prized for their multicolored feathers and because they had the ability to talk. In the center bowl is a trainer with a parrot in a hoop and another in a cage. Adorned with elaborate belt, sash, sandals and parrot mask, there is a quality of posture and costume as if performing for an unseen audience.

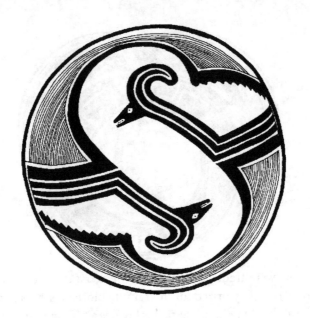

The often-illustrated big horn sheep held a special significance in the mythology of Southwestern Indians. Horns indicate power, usually the spiritual power of the animal that possessed them.

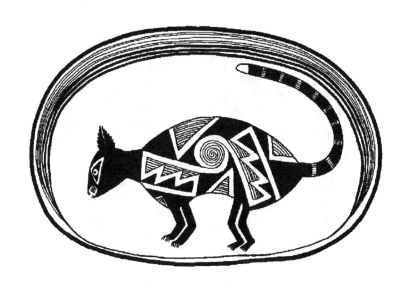

Would you identify this image as a mountain lion? Exaggeration of the mountain lion's tail is common. Notice in this bowl painting that the back feet have human toes and the legs are slightly elongated. This indicates that the image represents a costumed person.

19

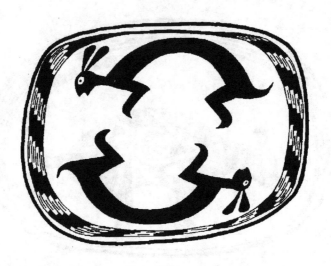

Many cultures around the world, including the Aztec and the Chinese, see a rabbit in the moon rather than a man in the moon. In pueblo representations the arch of the rabbit's body is often exaggerated creating the arch of the crescent moon. Another image depicting the relationship between rabbits and the night sky can be found on the front cover.

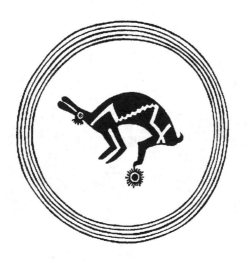

On July 2, 1054, a star exploded in the Tarus system. We know the exact date because Chinese astronomers meticulously recorded the details of the Crab Nebula Explosion. For twenty-three days, the star appeared like a second sun in the sky. In this image, the second body shown in the sky with the lunar rabbit has twenty-three rays. This may be the only North American record of this celestial event.

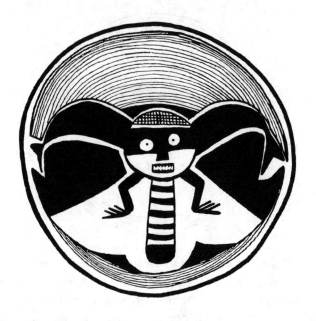

This buzzing companion, known as "Big Fly", was believed to whisper inspiration and insight if he sits on your shoulder.

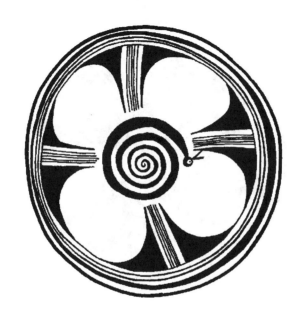

The insect's natural form is used to create and emphasize the symbol of the spiral. The frequent use of the spiral was to illustrate emergence from one level of existence to another.

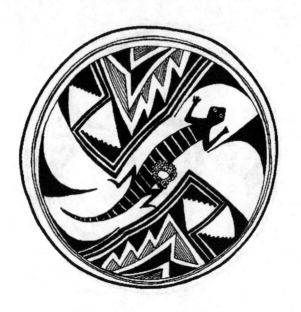

Lizards and geckos are frequently illustrated on ceramics and in petroglyph images. The lizard is a symbol of transcendence and is part of the pueblo people's creation legend.

In the creation legend, man evolved from the lizard. The lizard head stylized into a diamond shaped design with circular eyes is often seen in both petroglyphs and bowl paintings.

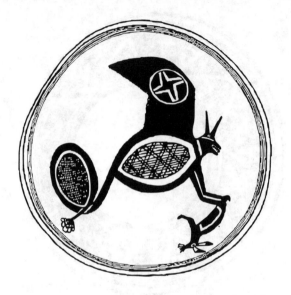

As a nocturnal image bats are often combined with other symbols representing stars or the moon. The cross pattern on the wing of the bat represents a star or planet. The rabbit is the symbol for moon. The moon is carried off by the stars to be reborn after a three-night absence.

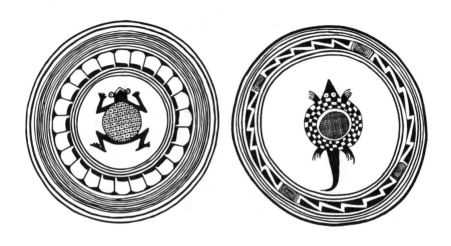

In pueblo mythology both the frog and turtle are water symbols. In what resembles a prayer stance perhaps the frog is beseeching rain for the precious corn crop. This idea is reinforced by the grid/dot corn pattern on his back. The back of the turtle represents the first of the dry land after the great flood that cleansed the earth.

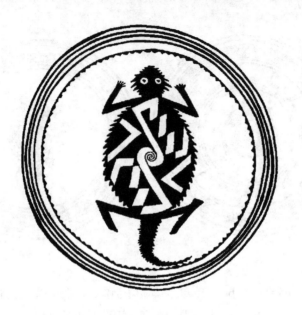

Common in the desert, horned toad images were often carved into rock surfaces and frequently appear in the ceramics of the Hohokam Indians.

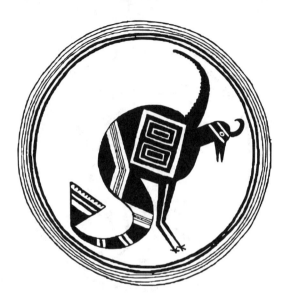

Prehistoric artists knew how to paint a bird that looked like a bird but this was usually not the purpose of the illustration. Animal combinations represented the ability and power of more than one animal. In this example the abstract bird has a long serpent-like tail.

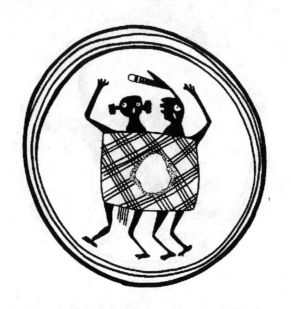

In Mimbres paintings blankets are commonly shown held up and hiding clandestine action. The hair whorls on either side of the girl's head indicate she is unmarried.

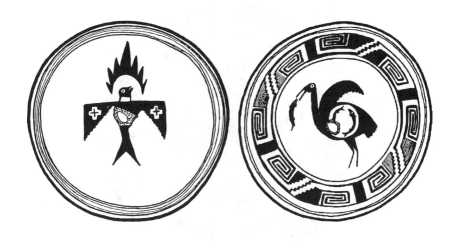

The bird in the illustration on the left is a swift. Swifts were believed to be guides assisting the spirit up through the kill hole. The outlined cross represents a star or planet. The terrace above represents fire or possibly the sun. The other bird depicted is a crane. This one is seen in a common pastime, swallowing fish.

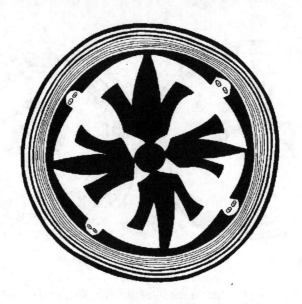

The color white is associated with death or a death-defying situation. There is little debate among researchers that the white images are ghosts and the black images are living. There is debate on what the living images represent. What do you think?